A Winter Triangle

POETIC JUSTICE INSTITUTE
Elisabeth Frost, *series editor*

A Winter Triangle

Marcella Durand
Foreword by Srikanth Reddy

Fordham University Press New York 2025

Copyright © 2025 Fordham University Press

All rights reserved. No part of this publication may be reproduced, stored in a retrieval system, or transmitted in any form or by any means—electronic, mechanical, photocopy, recording, or any other—except for brief quotations in printed reviews, without the prior permission of the publisher.

Fordham University Press has no responsibility for the persistence or accuracy of URLs for external or third-party Internet websites referred to in this publication and does not guarantee that any content on such websites is, or will remain, accurate or appropriate.

Fordham University Press also publishes its books in a variety of electronic formats. Some content that appears in print may not be available in electronic books.

Visit us online at www.fordhampress.com.

For EU safety / GPSR concerns: Fordham University Press, Joseph A. Martino Hall, 45 Columbus Avenue, 3rd Floor, New York, NY 10023, fordhampress@fordham.edu

Library of Congress Cataloging-in-Publication Data available online at https://catalog.loc.gov.

Printed in the United States of America

27 26 25 5 4 3 2 1

First edition

Contents

Foreword, by Srikanth Reddy ... ix

I. automata of a perpetual flute

Breath runs out ... 1
smile nicely ... 5
the water clock ... 6
the picklock's frustration ... 7
the etiquette of scribes ... 9
what noise of circles ... 10
a flower absent from all bouquets ... 12

II. Septentrional

in order to develop a septentrional ... 15
N ... 16
it has not ... 17
"Without invention nothing is well spaced" ... 18
seven not yet ... 19
constellations, as well as being imaginary ... 20
to cut, to cut out ... 21
rejuvenation ... 23
give caesuras a chance ... 25

the beginning of the opening	26
the map isn't right	27
Septentrional	29
S E P T	30
Heavenly Wolf Star	31
A heliacal star	32
where the spear points	34
Sirius, or the Wolf Star	35
Math hints	36
then we turn to the confines of the ship	37
calligraphic galleon	38
constellations are strictly regulated	39
constellations are regulated	40
infinity is made finite	41
in uneven shapes we break	42
calligraphic galleon	43
he whispers, don't tell the boss	44
seven sleepers written into the boat	45
can form	46
le septentrion aussi nord	47

III. a winter triangle

now is the time	51
the winter triangle	53
the winter triangle	54
in dustlike script	56
toward you with spaces	57

what noise of circles	58
the huntsman spider	59
Scorpius, with its three syllables and red heart	60
Stars that are interesting	61
curious to see	62
What I do is stand	63
How is it possible	64
she wanders into	65
counting leads to the idea	66
four for each chamber	67
silence is X musician	68
in form is some new strangeness	69
N	70
in a septentrional direction	71
"that" lies on the stage	72
if the theatre were open air	74
if the play, I mean, the universe	75
what sort of order	76
cast alight – cast	77
this new form of strange has to be understood	78
look to the cold brilliance of the winter triangle	79
it is not space that is eternal	80
war endures, as does poetry	81
Acknowledgments	83
Notes	85

Foreword

by Srikanth Reddy

"One's numbers must be in order," writes Marcella Durand, "and to order one's numbers, one / must listen to sounds carefully." This is sound bookkeeping advice for any reader, and especially for poets, who've long imagined their art form as sounding out the order of things, from Milton's "apt numbers" to the cryptological cosmologies of Mallarmé.

 Like *Paradise Lost* and *Un coup de dés*, Durand's extraordinary book transports us to a realm "where numbers end. / And begin again." One name for this "where" might be God. Or mathematics. Or another, with apologies to Rimbaud, might be oneself. "One has a chance to transform into zero," Durand observes, "if one takes oneself away from one."

 One might say that Durand is writing the most resonant French poetry in English today. Where the French pronoun *on* aligns the one with the many, Durand's preferred literary pronoun allows one to hear the numerousness of being in a different key:

one creates the day
one heralds the day

one's red darkens

Are these artists at work in their studios, or vast magnitudes of plasma revolving in outer space? They're one and the same—and so are we, in Durand's universal verse. Her "one" exists at the threshold of identity and anonymity, solitude and collectivity, singularity and wholeness. One is the onliest number, one comes to feel reading this book.

 A maiden. A scorpion. An archer. Constellations are figures, composed of burning worls, for the one and the many. Yet Durand names her book for a "more expansive, looser version of a constellation," the asterism known as the Winter Triangle. *The*

Winter Triangle. *A* Winter Triangle. Durand's shifting articles defamiliarize oneness itself. Like the Mesopotamian mathematician, the Han dynasty potter, and the Japanese roboticist she lovingly cites in her endnotes, Durand belongs to a tradition of religious and philosophical mysticism.

Durand loves *Star Wars* too, and buddy movie action-adventure thrillers, and grasshopper mice, and prosodic theory, among other things. *A Winter Triangle* is a self-portrait as human asterism. Arriving at this wondrous book's unfinished final sentence, we come to see what one can be:

my first name is war
my last name is endurance
and strangely I am a poet
inventing a new form of poetry
in the infinity of space
in manifestation yet to be

> ≠ a book can
> thus only contain
> a certain quantity
> of matter—its
> value—
> ideal
> without numbers that is
>
> —Stéphane Mallarmé, *The Book*,
> translation by Sylvia Gorelick

I

automata of a perpetual flute

Breath runs out at 8 and after that 12.
Air turns line at two times 4.
No air after three times 4 unless silent e
carries vowels past that line.
That line. Why math it?

8 is the boundary of memory.
By 12 one becomes forgetful.
Beyond 12 the line loses its vibrancy.
Back to 8, double the time of the heart
with its four chambers, so a line is heart divided in two.
More than that sequence, language becomes machine,
and machines are not memorable.

In time of strange effusion, is it allowed
to count to 12 again or must I conform to
beat of 8, deemed most effective to convey
within medium of letters following one after
another doubled beat of heart before escaping
past reach of brain: but who says brain, furrowed
with infinite folds, can't follow 12 syllables past end

of line into misty realms, who says gray can't be
million shades of water, cloud and winter, who says
winter is not warmer now in changing skies, who
says every shade of color isn't more attractive than
monotones that dull our eyes and train our tongues to
beats that end before brain and much less heart begin?

Who says 8 is more than 12
or 4 is more than 8 or so on
into zero and backward to before
it all began whenever that strange
knowledge of what is always
bending back to what is to come.

Where numbers end.
And begin again.

smile nicely

water and candle clocks
fountains change their shapes
automata pour drinks
water pours out of peacocks' mouths

automata with semiautomatics
ten face off against the other ten
ten move fingers up and down with a stick
automata smile nicely and pour drinks

bees carry ropes on their backs
ropes covered in pollen
sacks suspiciously yellow
thieves who stole my flowers!

ten loves every other number divisible by ten
ten wonders how to fit three or four
ten desires to be a hundred, a thousand, or a million
ten contains all numbers and reaches for more

garden filled with automata
uncanny valleys under the moon
move and moving strangely
water pours from the uncanny moon's mouth

the water clock

The hands are leaves
as are lines that lead
from center to home and
places of direction are colors,
maybe arranged oddly, green
shading into purple, not a strict
progression of spectrum, but more
undersides of trees at evening,
day changing from luminous
to tenebrous—diurnal structure
that expands and contracts, powered
by some glimpse of shade. Uneven stream
bed complicates progression, so water makes
a sound somewhat like a car hum, which
trails to the hush of a spider building
a web. The entire machine floats,
a museum to silk and scissors,
suspended on the fabulousness
of experience together held
in circular returns to
twelves and centers.

the picklock's frustration

The lock is a masterpiece,
which the maker submitted
when applying for
membership to a guild.
The keyhole was deliberately
concealed and can be used
only after releasing
a panel on the back
of the lock by means
of a hidden mechanism.
Various other movable panels,
revolving shields etched with
coats of arms, and circular
apertures in the lock are
meant to confound
all efforts of the picklock,
of whom there is
only one, and of whom
we will never know
his or her face(s).
Even now,
the picklock escapes
over the sands

and snows
of the endless
spectral and fierce
ranges over yon,
carrying this
very lock
in a pocket,
not the dupe
we look at
through glass,
mystified as ever.

the etiquette of scribes

Understand the proportion of one letter to another
and of your emotion in proportion to mine; this selfishness
is intolerable! I deserve better missive, or an apology
the depth of an ocean comprised of centuries
of hurricanes of tears, oceanic sobbing and contrition,
clouds eternally closing over the globe, hunkering
down in an earth of mud sinking into its own regret
over having treated me so very badly!

what noise of circles

Poetry is silence's
musician and in

painting corners
malachite against

vermilion, while
orange springs.

Outside, pine transitions
to amber, resin to wood,

resin to eye, similar
to drop shape of eye:

what looking through wood
is like, through patterns

sawn through timber
or water as it wanders

through rocks or rocks
wander through water—

pebbles imperfect circles
of a color not of earth.

 for Michel Durand

a flower absent from all bouquets

where to begin O where to begin
a distant flute sounds over the terraces

played by a bee disappearing from the forest
or a fly disguised as a bee or a camera

disguised as a fly disguised as a bee
blowing into a small silver flute that sounds

when a strong wind blows from the north
if left on a table on a balcony during a storm—

unlike so many flutes, this flute plays
to random breezes, it will tell

which direction a storm may be coming;
it does not require human interaction or even interest,

a rare invention that benefits both the earth
and people because it makes music

from recycled materials foraged
from plants pollinated by mechanical flies.

II
Septentrional

in order to develop a septentrional
one's numbers must be in order

and to order one's numbers, one
must listen to sounds carefully.

I hear: a high-pitched whine, a metallic thunder
that blends with my own thoughts of how

difficult silence is to find and when found
eardrum noise is just as loud; it is almost

as difficult as finding darkness in a city.
Until then, an approximate double

dactyl, a weak form, a shadow of
true form: does not have sound but is not silent.

 N

the septentrional will be the resolution
of form, within seven syllables
and yet have the feeling
of wind blowing
through it; it has
not quite resolved
to its numbers

 S

 it has not
 resolved in form
 yet; it needs
E to be quiet and to find direction W
 and external reality persists
 in noise and distraction

 to search through numbers
 all the numerals
 when they were first
 invented, to think
E to be away W
 from

 silence

"Without invention nothing is well spaced"

To find silence within a form
To find silence along the line
include a space, a caesura as large as one wants it to be

include a space a caesura a place for wind to come through

a space within the line/inside the form for air to enter
instead of turning at a wall of words, to turn otherwise
and travel somewhere else, to blow away

a space within the line as the line could be
a place for invention could be where the new is invented

seven not yet

bounded by seven,
seven syllables could be the boundary
of the line to be invented
and again, the space, *caesura*

the page is a sort of sky
we are not entering the realm of seven just yet
we are thinking about the space of the line
and what/how to invent within that space and along that line
a space of development and variation

*"unless the mind change, unless
the stars are new measured"*

constellations, as well as being imaginary, also comprise spaces between stars
as well as the stars themselves
assembled where they might be
assembled by the mind assembling them
even as they are where they might be
fallen where they might fall
tumbled as they might tumble
not placed except as the mind places them, and then connects them
as line connects between star and star
as line resolves into an arm, a tail, a belt of stars
only color betrays the randomness
or as far as we think it is random; it seems connected but also random
it seems assembled and placed, or it seems to be random whatever
debris or enlightenment
meaningless or meaningful; it could be either or both or all
the *constellation* could be either or both or all
and the form could follow that, but as a definite place of assembling,
a deliberate place of placing and placement,
except spaces between allow
for some movement, some reconfiguration
of what we see in between stars
and lines may shift from one point to another.

to cut, to cut out

I am thinking of
a caesura, a place to rest,
to allow air,

it could be placed after the 3rd or 4th syllable in a 7-foot line

but then I read that an extra syllable
before the pause was forbidden
by Pierre Fabri and Jacques Peletier du Mans
in their *Pleine rhétorique* and *Art poétique*, respectively,
in 1521 and 1555, respectively, and du Mans
was the first to use
the term
césure
in French

césure means
"cut"
or
"cut off"
it could also
be "cut out"
as in a Caesarean

which I thought
named after Julius
Caesar and his mother,
being the first co-recipients
of a now overcommon procedure
in a continuingly Caesarian culture

But *caedere*
is a Latin verb
meaning "to cut off"
and all variations
derive from that root.

caesura is not "to cease"

it might be to continue

on after a rest

to soldier on?
to endure
to persist

after a rest

a break to allow
rejuvenation
within the line

rejuvenation

rejuvenation is a term with four dots that indicate high frequency in current usage, often used to describe botanical, biological, or geological processes:

> *the uplift rejuvenated a river valley*
> *politicians are rejuvenated by infusions of vampire blood*

but perhaps most importantly rejuvenation is used
to describe how a soil system is returned
to an earlier state (not through "development"
but the opposite, "undevelopment," or "rewilding"
or "laying fallow" or "leaving it the fuck alone")

seeds brought by plants
seeds dropped by animals
seeds wanted and unwanted
we wait and intervene
selecting, if we have labor
and funding, which
plants get to stay
and which get ripped out,
feeling down stem
to find the end of the root
and then, pull

tubers and legumes
legumes and tubers
tubercles on the lips of cacti
through a sub humus network,
a mycelial drive through ecosystems,
through worms who digest plastic,
lumbricina carbon capture possibility

we may have forgotten, actually
how soil is formed
so, instead, let it blow away
let invasives take over
let soil be buried under skinny skyscrapers
let permanent shadows fall upon it
let long shadows fall upon the fields
let the fields of sun be in darkness half the day
let half the day be dark let
it be completely unproductive
let us not put each tree in a pot
let us not make trees be decorative
let us not inspire
trees to hate us
let us not hate
trees; let us not
hate green things
let us let them alone
let us let them be
with each other
in abundance

give caesuras a chance to enchart
a facilitation of Humboldtian lyric expansion,
leave Antarctic-sized spaces

 in the center of sky or ice
 glacier opens soil

continent ocean
vast but not empty
full of everyone
and who do NOT
erase or assume

amid populations, peoples and people
illusion of nothingness; dissipate illusion
of emptiness, of wilderness: there is no such
thing as wilderness, it is an illusion invented
to invade spaces that belonged to—or people
who belonged to spaces. Belong to their
spaces. To each other, they belong.

the beginning of the opening, the caesura
a place to pause and breathe, or be frozen
place to freeze, stop
arrest

space of arrest
what sort of space to arrest, to stop, to freeze
pause, breathe, or not breathe in space of arrest
is that what this space is, being developed, to freeze, melt or reveal

"we still can't get the maps right;
there is still a need for revision"

the map isn't right:

septentrional is an adjective after all,
 "of the north"

"of the northern countries" and is redolent ? of colonial

?

septentrional

the sound is lovely, but connotations . . .

used on maps to indicate "unexplored" north area

away from the south

far
from
the
south

no equivalent term for "of the south" "of the southern countries"

the usual antonym is *meridional*

so *septentrional* might lack equivalency and balance
as does seven, an odd number

inherent in seven and the *septentrional* is loss
and absence

try to

sing of seven

septentrional

the plough-ox

the seven and sevens
seven of even of s
s is evenly distributed through curves; it is *even*
even sibilance

Septentrional

is of the north,
is of the seven stars of
Ursa Major: earth turns north
to constellation—turns to
forests, desert tundra and
settlements, darkness of
land contrasted with sea.

Sea luminous, sea encroaching.
Lightness of sea all reflection
or internal phosphorescence.

Sing
of the Septentrional!
Of the seven stars
of the Great Bear!
The Plough-Ox!
The Boreal Spoon
circling season to season,
visible through quickly increasing haze
of our breath!

SEPT

all words beginning with S E P T
may not even be connected
instead *sept* is a coincidence
a coincidental gathering of similar or exactly alike letters together
sept is also an architectural feature
a gathering at the top of a frame
or a clan, an alteration of *sect*
a sect at the top of a frame

the word *septentrional* sounds so lovely
or military sounding?
what in its sound is it?

five syllables when it connotes seven
using it alone in the idea of the line of the septentrional
I am fashioning would already use up most of its measure

it would only leave two,
two spaces for syllables

Heavenly Wolf Star

On the Western Han vase in the museum,
the mounted archer represents the Bow constellation
that keeps the Heavenly Wolf star under control:
The Bow constellation points its arrow
at the Wolf star to prevent the Wolf star
from leading the cosmos into chaos and strife;
but in different times the Wolf star chafes
at the eternal vigilance of Order, straight-arrow
Bow maintains rules whether good or bad, Bow
continually enforces order and deadens progress
or protest. The Wolf is drawn with an incredible
energy, all purple and speed lines, while Bow
is almost invisible among its constituent stars.

A heliacal star

The Wolf star oversees thievery and looting
but what when accuser is also a thief?
What when enforcers of law become
above the law/lawless?

Why the mirror is important
and what is looking back. When the size
of an image increases by 10 billion magnitude.

But the Wolf star is also the Dog star,
or Sirius, *Seirios*, which means "glowing"
because it is slowly moving closer to
earth and as it moves closer it will burn
brighter before it dwindles.

A *heliacal* star, it rises before and
sets after the sun. First and last visible,
when it emerges from the sun's rays
when it brightens behind helio-electric emanations
when the sun passes through any of the 12 signs
when the rivers flood and dogs lie in the heat.

Other brighter stars more distant seem dimmer.
How distance creates a perception of unimportance.
When those small points are actually burning, importantly,
and need to be seen clearly.

where the spear points

The Wolf/Dog star rises with the Sun in July and August
during the long days named after what the star is named after.

In the predawn sky in August you will see the flashing Wolf star
held back by the invisible consortium of stars in the Bow constellation.

The stars arrayed behind the arrow give the Bow constellation its power.

The community of stars imagined together to explain the star
at the tip of the arrow rising at predawn to challenge the sun.

Sirius, or the Wolf star, is actually Sirius A
and there is a Sirius B.

It is an Alpha Canis Majoris B
as the Wolf Star is an Alpha Canis Majoris A.

They orbit each other and
one wobbles.

The Bow constellation aims its arrow at the large bright star and its dimmer partner.

Sometimes Sirius A is the star at the arrow's tip
in other interpretations
of constellations and asterisms.

The star is either the enforcer or the recipient of force.
It is the law transforming into lack of the law.

Math hints there may even be an Alpha Canis Majoris C.

Math hints at a smaller partner circling the larger partners, older and fainter.

Seen in the math, in the equations

as numbers pour in via radios and telescopes.

Back to form, as so much infinity is frightening,

infinity of stars gathered behind point of the arrow.

then we turn to the confines of the ship—to find a *septentrional*

a constellation amid the skies, eye traces lines between dots

an asterism, more expansive, looser version of a constellation

calligraphic galleon

in the shape of a ship we might see all this

boundary of wood, waves written in "dustlike" script

writing in the shape of wave, boat, wood, desk, desk of boat and desk with no view of sky

all this imagined, as constellations are imagined

as the ship is written into visual shape

something for the eye to see and that image

to travel the close-to-infinite distance from eye to brain

constellations are strictly regulated; one cannot just imagine one

constellations are mostly named after Greek mythology

once-colorful statues stripped of their colors

whether by weather or culture

a culture that worships and fetishizes the absences of color

red star shines in a shoulder

and dark blue, black yet surrounds them

and eye traces its own shape among them

in places away from the decrees of meridionals

constellations are regulated and named in eights
8, a number forced into curves of itself

8 circles with no pause, break, or caesura
perfection leaves no opening for breath

perfection leaves no chance for change
8 broken is four, then two, then one

broken into two zeros, then, and an opening
if one takes oneself away from one

infinity is made finite
into a number only as human observes it
and recounts it to others

infinity can break upon the finite
as space might be finite
and solidity perhaps not

water breaks upon sand
breath breaks into air
eye breaks space to stars and lines

in uneven shapes we break
from seven to five and vacillate wildly again
why choose order over disorder
why chaos over order, why order over chaos

hunt not with bow, hunt not wolves or dogs
coursing about the cosmos, tail a star, eye a star

train your eye upon a spot and aim with lightspeed
by the time light reaches us, it is already dead
perhaps, says the viewer, who is young and at
the beginning of understanding mortality,
which might be less frightening than infinity

calligraphic galleon

the boat is written in "dustlike" script
the boat ploughs through the waves
a composition of waves painted from a composition of waves
built of a complexity of elements interacting via numerous laws of physics

a cold way to look at it, drawing from photos
who would know that she draws from photos

surfaces reveal their possibilities
pencil on waves from an image; waves similar and never not
boat built of script, not words, italics were meant to convey a human hand
the reproduction of a hand, a mechanical welcome to the script

the automaton sits until the button is pressed
the man sports a top hat and a waxed mustache; he whispers,
"it would be better to buy the guide to becoming a magician in English"
he whispers, don't tell the boss

he whispers, don't tell the boss

Tap on rings to make them separate
Blow on rings to make them come apart
Blow on 8 to separate 8 into 4
4 is closer to the heart
Tap on 4 to transform to 2
Blow on 2 to break to 1
It would be better to buy
the guide in a language
you already know.

seven sleepers written into the boat
sleeping in the space of a caesura
in the rest a comma provides, that breath

seven sleepers
sleeping their way through a loquacious era

while sleeping I dream why I am so intent
upon inventing a new form
a form to accommodate intemperance and inarticulation?
a form to allow air, a place to break

can form as it is invented be interpreted
does interpretation drag upon process of form, formation

I think it might be up to you to interpret my intentions in inventing this form

the only thing I want "it" to "do" is open and point toward seven stars

"the Seven Stars the North as well"
I dream an alternate translation upon the shelf

le septentrion aussi nord

septentrion does not want to be translated as "seven stars"
septentrion means septentrion in whichever language
it is a word already translated in itself

 the septentrion also north

septentrional is a noun, it is a form of poetry
that includes a caesura, a space for change
it is difficult to see any part of the form, but change

III

a winter triangle

now is the time to gesture toward a triangle
a cold triangle not just because it appears
during the winter but
because it is in space very cold
and yet for seconds people seem to survive

especially when powered by the force
and the woman floats back past age to regain herself
she lifts her finger just barely in the vacuum of space
and her body, asleep but with her dark eyes open, moves back
to the safety of the ship: the landing dock is bright, warm and open; she moves
back to her own warmth, her dark eyes open

but

as she moves she observes the cold sky above her
and surrounding her in depth and filled with stars
more than stars but all the phenomena of combustion
matter and energy above and around all of her, to the fingertips
and each eyelash of her frozen eyes

below her are stars, on each side too: out here "side" is meaningless
—instead it is *around*, all *around*, *round space*
the depth and richness and light of *round*
where circles expand into something indescribable.

the winter triangle
knows its time
rises high
made of three

is difference of colors: white, red, green

but the winter oval
but the winter hexagon

as long as stars are bright
as long as the stars are the brightest

the winter triangle
is defining vertices
with Saturn below

as Saturn is below and
alliterative with seven
as Saturn is the seventh

Saturn is the seventh, but
before you clamor to tell me
that is "wrong," that Saturn is
the sixth planet—

the sixth planet
should be Jupiter: but
Saturn has that strangeness,
an oddity of its rings

the oddity of its rings
only seven, when
eight would make
them complete

complete, without errors
in its numbers, and rings
falling apart, as are numbers

as are numbers; the Kuiper Belt may
be thousands of planets but
before you tell me I'm "wrong"

before you tell me I'm "wrong,"
Pluto should be allowed
back into solar progression

in dustlike script

as you wish sleeper
I would not wake you with a firecracker
or emptiness at your center as I say
writing toward you as you are

at the end of some coastline as refreshing as bottled water
in a barrel of ice at a corner deli
into which you dip your fingers

we went there and got assuaged
you remember what happened yesterday
another chronicle and if drawing a circle on the street "you" Max Erns
"you" armillary sphere "you" bird shape

form disintegrates when chalk touches the sidewalk
so hot not to accommodate form upon concrete
what form will hot concrete accommodate?

toward you with spaces
a collection of walls or
ready for spray paint
done yesterday and then

breathing slightly through mouth
couch night desiring breeze
I would never buy that

on the peculiar squareness of gardens
as though watched by a building
if written on another day
as though y is constant to i

many bodies many not you
as chalk meets sidewalk
mysterious in their random

I look and find you
objective chance
asks but I say no I am late

backs of easels
pull-down gates
commission
what of it, the edgy ad

humid air and fan
reading what's on the table, a freebie
and only read it at night, sleepless and vague

which looking and not looking feeling
slight haze rises from lake masquerading as ocean
a separate collection of thoughts but constant "you"
i over x equals y as though you

vague and then take line suddenly
 constellations of gum
arrangements because they *were* spit there

as though pre-arranged to meet on a corner
connects us to our desire and the universe
 late to meet you and you have already
 circumnavigated

what noise of circles
 after Vija Celmins

on this scape spaces of what I have written
 on spine up ankle the curve of woman (I) lying in cyclorama
 I consent not to have my body be constellation or skyline
traces of forms I have worked through

what I have done is reversible this way and that, script and spine
rotate and fall through color to arrive
at each interpretation of which there are million millions, you choose many

 on this graphite on acrylic ground is choice, then reproduction
 but reproduction so close to effort to understand what is an original
 in reproduction is search for truth, and looking—looking so
 intense as to result in grays and browns, a spectrum of restraint,
 a restrained spectrum—reproduction becomes an original
 in the worked-over surface, worked-upon to its own being
 of grayness almost encaustic and choices of originals, of truth

in shift of air through color are erasures so quick
before anyone knows it is deleted and replaced with ∫
∫ as curve in comet, comet in original is compositional element
composition is random, scattered, expanded, opens to air
stars, rocks, waves—almost infinite elements invited to composition

the huntsman spider

the huntsman spider travels into the desert at night,
meets another huntsman spider; they clash but do not fight
the huntsman spider has already memorized constellations of the night sky
to find its way among the grains of sand back home
it closes the sandy door to its small tunnel after it
as the male gecko cries for the female gecko to travel under the owl sky
and the grasshopper mouse devours the scorpion glowing under twilight

Scorpius, with its three syllables and red heart
a red star in center of constellation being
as scorpions glow in ultraviolet light
scorpions make hearts to each other
in the desert, stinger to stinger

beware the grasshopper mouse, Scorpius,
beware its sweet jeweled eyes watching your heart
it is immune to your sting; it howls at the moon
after dragging your shell toward your red star heart

Stars that are interesting: Antares, Sirius, Procyon, Betelgeuse

four
+ the sun
= five stars

three belong to an asterism;
one to a constellation

three to the north
one to the south

one barely rises above horizon, north
one is visible at dawn in late summer

one is not as familiar as the others
two are red
one is blue-white
one is usually the eighth-brightest object in the night sky
one is always the brightest object in the day sky
one creates the day
one heralds the day

one's red darkens

curious to see

day marks us within time and imagine that
within all time on one side and the other
to the North and to the South
is one day and

one day
may turn into another

at the top, shades gray, blue, brown, black, ink

blues are vivid and become points of color
lately the skies have been violet after sunset

I take space within the city, I move about it with qualms
what I would do is wander around alone at night because
I am curious what stars I see in the city: bright Orion,
Big Dipper low on the horizon, Mars, Venus,
Sirius at certain times of year. Anything at the apex of sky.

Inside triangle created by walls, buildings and avenues.

What I do is stand on my terrace at night and early morning.
I wander and then have a drink at a bar alone and strike up
a conversation about stars, I get into a fistfight broken up
by myself wandering the city at night, looking for
malfeasance

How is it possible, except in a dream, for a city to be so dark?

A box filled with objects so dark in the middle of a white room?

Objects painted dark blue and a doorway not to be entered?

Light ends at the door.

The plazas are light, they are semicircles of light into which alleys empty in darkness.

she wanders into a night of vanishing perspectives
she follows a line into an emotionless space
she wonders, while writing it down, how emotion is linked to cognition
evidence shows emotion is linked to cognition
it is increasingly demonstrated that emotion is linked to cognition
and he wonders how the two ever got separated—is thought not feeling?
Is feeling not thought? Are tears not liquid manifestation of understanding?
She asks, he wonders—do we perform acts the opposite of which category or
are we seven steps away from the sun,
looking into the sun having forgotten the special glasses
and not knowing why the corona appears as spectrum of seven rays

counting leads to the idea
that hearts are small versions of suns
so the sun counts in four—one count for each chamber
 four steps in
 eight steps to the surface of the sun
 after eight spaces we dive under

explosions—and the line breaks there
after eight the brain will forget

four for each chamber
we hide in from corrosion, corruption, institutions
the line of the spiral has at last met the center of the spiral

chamber of hotels, the bed chamber, chamber of heart, heart changer
pray in the chambers far under the caves
as if heart's middle is the ground floor
and below that circulates a constellation

if objects became vacancies
stars become black holes
the most intense nothingness there is

if stars do that
what does the heart become?
remember the number four
to count to four
upper, lower
right, left, nose, mouth
beats of breath, where mouth-air reaches

then, write in new form

silence is X musician
music is silence in time
no, not quite right
still need time get map right
X is silence, musician
X is earth trembling between air and anxiety
no, earth is X trembling in anxiety
anxious earth
anXious earth

look for others
and then call out
in threes: three points
each one, top, bottom, side side

sides fall in
from spacious base
then narrow

aim at wolf
sharp arrow triangle

in form is some new strangeness

space is infinite, but time . . . ?
time begins, which connotes an ending

while space is a horizon over which is seen another horizon and horizon after that
"like ocean"

how lines unfurl themselves into length toward the horizon
draw themselves to the left although pulled to the right
left may be unexplored north, far from the south;
dust door opens and closes
under the blue light of change making us all glow

 N

W E

 S

 S

 E W

 N
 N o S O S o N

 son us sun

 sun, us, son, form

in a septentrional direction

one moves north, to the north
northerly, in a septentrional direction, at which point one leaves the city

and the length of the line unfurls toward a horizon and when we arrive
at that horizon there is a horizon after that

after that
to write a poem around "after that"
to write around and about and "into"

"that"

"that" lies on the stage, palm up, fingers slightly bent
stage light throws shadows
because of acoustics whispers abound

pssss pssssss pssssssss

watermelon cantaloupe watermelon cantaloupe

but not a conversation exactly

trying to hear, cupping the ear
tipping forward, falling forward
falling into the sound
of other voices gathering
when everyone is invisible

the audience hasn't entered the theatre yet
the seats—red velvet—are empty
resonance of red velvet
resonance of a red carpet
inviting the audience to enter and attend
to hear pattern in the whispers

the whispers coalescing into a semblance of vocabulary
then sentences, and
production

if the theatre were open air
if the theatre were open to sky

stars become actors
constellations the script

galaxies special effects
the effects of distant explosions
because distance may be violence
the universe is explosion and violence,
and car chases

if the play, I mean, the universe
were a buddy movie action-adventure thriller
and the bodies of men infinitely reflected
six packs stand in the front and refracted
square jawed—refracted
hands on hips, weeping
shoulders, compacted
bowed under the weight
of their muscles
what number are they
in the mirrors bowing endlessly behind them
where is the one
with the arrow
to step forward
and maintain order?
is there no one?
is there many behind the one?
behind the point of the one?

what sort of order
is a cheap acrylic
mirror lined with foil
photographed on the cell
photographed again

and after that
"after that"

frames sped 24 zillion per second
unwatchable except
on the inside-eyelid screen

cast alight – cast – gasp – ding
gasp gasp a scene startles – major foot lifts
helicopter rotor – pulls back hair – tie flies
just announced – of great importance – sets precedent
tie flies – buttons jacket – I am with – mouth agape
into sun – sun is

this new form of strange has to be understood

the hidden/lost painting came into view for a month and was sold for gazillions
between airports and divided into shares and investments (oilman owns half)
the artist would have set them all on fire or would not have painted
the painting if the artist had known
where the painting was going to go

the wood frame is infiltrated by little spaces
footprints in the tiles make the tiles more prized
coyotes or birds may walk across
worms may burrow into the original wood frame
as smoke may accumulate on its surface

may the new "owners" not fill these holes with wood glue!
may the paint burn their fingers!
may their bank accounts drain away into the wormholes of their souls!

look to the cold brilliance of the winter triangle
wander through night of vanishing perspectives
and over rocks that wash into mineral seas
under flat gray skies never to be in color
as vision is always heading to black
as what is looking at art and sky anyway
as Mars/War takes uncertainty
and travels directly to

it is not space that is eternal
we find the infinite in time

in "eternal" "city"
in never-ending city

what will we make
of space, what will
we compose
out of senseless splendor

war endures, as does poetry

may film stills be a constellation of stars?
all glossy lips and marcelled hair
furlike eyelashes throwing long shadows down cheeks

their hair named after me
me named after the god of war

Bow takes on Arrow
Arrow shoots back

my first name is war
my last name is endurance
and strangely I am a poet
inventing a new form of poetry
in the infinity of space
in manifestation yet to be

Acknowledgments

To my father, Michel Durand, who passed away shortly after *A Winter Triangle* was chosen for publication. I am very grateful that I could share the happy news with him during an otherwise sad time. A few days after his passing, I opened a box of his old photos to find a postcard with the image of an automated peacock from Al-Jazari's *Book of the Knowledge of Ingenious Mechanical Devices*: a moment of love and connection amid the infinite. Thank you Elisabeth Frost, for understanding the meaning of this image for the cover of *A Winter Triangle*.

To my mother, Suzan Frecon, who creates space and abstraction within composition. To Basha Durand, for filling sadness with potential for joy and transformation.

To Ismael, my "son/sun," and Rich, always.

Deep gratitude to Srikanth Reddy and Elisabeth Frost at the Poetic Justice Institute and Fordham University Press for their wonderful generosity and care with this book.

Thank you and love to Brenda Coultas, Jennifer Firestone, Tonya Foster, and Karen Weiser for their reading, advice, encouragement, and deep friendship. Thank you to Sylvia Gorelick for her splendid translation of Stéphane Mallarmé's *The Book*, which opened the door to constellations.

Thank you to the Foundation for Contemporary Arts for providing financial support at a crucial time for the writing of *A Winter Triangle*.

Thank you to the editors of *About Place Journal*, *La Chant de la Sirène*, *BathHouse Journal*, *Jacket2*, and *Fence* for publishing poems from *A Winter Triangle*.

Thank you to T Space for including "may film stills be a constellation of stars" in a poster and brochure for a reading, performance, and exhibition of Suzan Frecon's work summer 2022.

Thank you to the Metropolitan Museum of Art as a space of inspiration for this book, particularly the folio pages from the *Kitab fi ma'rifat al-hiyal al-handasiyya* (Book of the Knowledge of Ingenious Mechanical Devices) by Badi' al-Zaman b. al Razzaz al-Jazari, AH 715, included in the 2019–20 exhibition, *Making Marvels: Science and Splendor at the Courts of Europe*.

Notes

The winter triangle is an asterism comprised of three stars, Sirius, Procyon, and Betelgeuse, that appear to create an equilateral triangle. The winter triangle is visible during winter evenings in the northern hemisphere.

Sirius Procyon and Betelgeuse
assemble themselves
no matter what position they hold
as they are three they
are a triangle—the *tri*
is forever true

automata of a perpetual flute
Section title is drawn from "Design for the Automata of a Perpetual Flute," included in the *Kitab fi ma'rifat al-hiyal al-handasiyya* (Book of the Knowledge of Ingenious Mechanical Devices) by Badi' al-Zaman b. al Razzaz al-Jazari, A.H. 715 https://www.metmuseum.org/art/collection/search/642352

breath runs out and after
A study by Microsoft Corporation found that the average attention span has dropped from 12 seconds to 8 seconds. If syllables are somewhat like seconds, does this bode badly for alexandrines? "You Now Have a Shorter Attention Span than a Goldfish," *Time*, May 14, 2015. https://time.com/3858309/attention-spans-goldfish/

smile nicely
Inspired by Al-Jazari's innovations in automata, as described in the *Kitab fi ma'rifat al-hiyal al-handasiyya*, which are mostly grouped in 10, including peacocks powered by water. However, one automated girl serves drinks. The concept "Uncanny valley" was invented by Masahiro Mori, a professor at the Tokyo Institute of Technology, to

describe when robots approach the appearance of being human to the point that they appear repellent.

the picklock's frustration

"Disguised by numerous dummy holes, the real keyhole is revealed when one of the shields is turned to the right, releasing two bolts, unlatching a cover inside, and causing a panel to slide up." Padlock and key, André Omereler, 1531. https://www.metmuseum.org/art/collection/search/202001

what noise of circles

"poetry is silence's / musician" is based on a line from Stéphane Mallarmé, "Musicienne du silence," or "Musician of Silence" ("Sainte"), and rephrased by Quentin Meillassoux in *The Number and the Siren* (Urbanomic, Sequence Press), 64.

a flower absent from all bouquets

"The flower absent from all bouquets," Mallarmé, from "Crise de Vers," translation by Rosemary Lloyd in *Mallarmé: The Poet and His Circle* (Cornell University Press, 1999), 233.

Septentrional

I first encountered this term when translating Michèle Métail's book-length poem, *Les Horizons du sol* (cipM/Spectres Familiers, 1999). The word indicates a vague idea of "north," or an area toward the north, or the northern area of the sky. Mallarmé uses a variation of the term, *septentrion*, most famously in *Un coup de dés jamais n'abolira le hasard*, or *A Throw of the Dice Will Never Abolish Chance*. Graham Robb in a 1998 review of *The Meaning of Mallarmé: A Bilingual Edition of his 'Poésies' and 'Un coup de Dés'* points out an "error" of translating *septentrion* as "the symbol of infinity, a glittering constellation of seven stars." I tried to translate *septentrional* into English, only to discover that it already exists there with the same vagueness.

To find silence within a form

Epigraph: William Carlos Williams, *Paterson*, 65

constellations, as well as being imaginary

Epigraph: William Carlos Williams, *Paterson*, 65

to cut, to cut out

"Caesura," in *The Princeton Encyclopedia of Poetry & Poetics*, 4th ed. (2012)

the beginning of the opening
Aaron Sachs, *The Humboldt Current* (Viking Press, 2006), 36.

Heavenly Wolf Star, A heliacal star, The Wolf/Dog Star, Sirius, or the Wolf Star
Drawn from the mythology depicted on "Covered Jar (Hu)," China, 2nd–1st century BCE, in the collection of the Metropolitan Museum of Art. "The iconography is celestial: the blue beast represents the star Sirius, known in China as the Heavenly Wolf, and the archer is a personification of the adjoining constellation, Bow, whose arrow always points directly at the Wolf." https://www.metmuseum.org/art/collection/search/49539

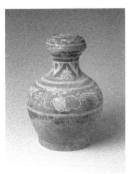

photo by author

then we turn to the confines of the ship, *calligraphic galleon*, seven sleepers written in the boat
"Calligraphic Galleon," AH 1180/AD 1766, in the collection of the Metropolitan Museum of Art. "The hull of this sailing ship comprises the names of the Seven Sleepers and their dog." The hull of the ship is written in *ghubar*, or "dustlike" script. https://www.metmuseum.org/art/collection/search/454611

can form
"the Seven Stars the North as well" is quoted from Jeff Clark's translation of Mallarmé's *A Roll of the Dice Will Never Abolish Chance* (Wave Books, 2015).

le septentrion aussi nord
 From *Un coup de dés jamais n'abolira le hasard*. Retranslation of same line by the author.

now is the time
 Princess Leia reviving herself in the vacuum of space, in honor of Carrie Fisher.

what noise of circles
 Inspired by Vija Celmins's exhibition, *To Fix the Image in Memory*, at the Met Breuer, September 24, 2019–January 12, 2020.

the huntsman spider
 Grasshopper mice hunt and eat scorpions, then howl at the moon.

look to the cold brilliance of the winter triangle
 "Senseless splendor" refers to Mallarmé's concept of how creativity intersects with infinity, a concept that reflects back through the entire manuscript: how to create a poetic form to accommodate the enormities of war, climate change, vast coldness, automata, technology, music, winter?

Marcella Durand is the author of several volumes of poetry, most recently *To husband is to tender*. She is the recipient of the 2021 C.D. Wright Award in Poetry from the Foundation of Contemporary Arts and the co-editor with Jennifer Firestone of *Other Influences: The Untold History of Avant-Garde Feminist Poetry*.

POETIC JUSTICE INSTITUTE

Adedayo Agarau
The Years of Blood

Marcella Durand
A Winter Triangle
foreword by Srikanth Reddy